30 AMAZING MANDALAS COLORING BOOK

Created by Angela Ronk DBA
TechneGraphix Graphic Design
www.TechneGraphix.com
Email: TechneGraphix@gmail.com

© 2016 Angela Ronk

Published by CreateSpace August 27, 2016
Williamsburg, Virginia

All Rights Reserved by Angela Ronk

DO NOT DUPLICATE, Doing so infringes on the copyright that is owned by Angela Ronk

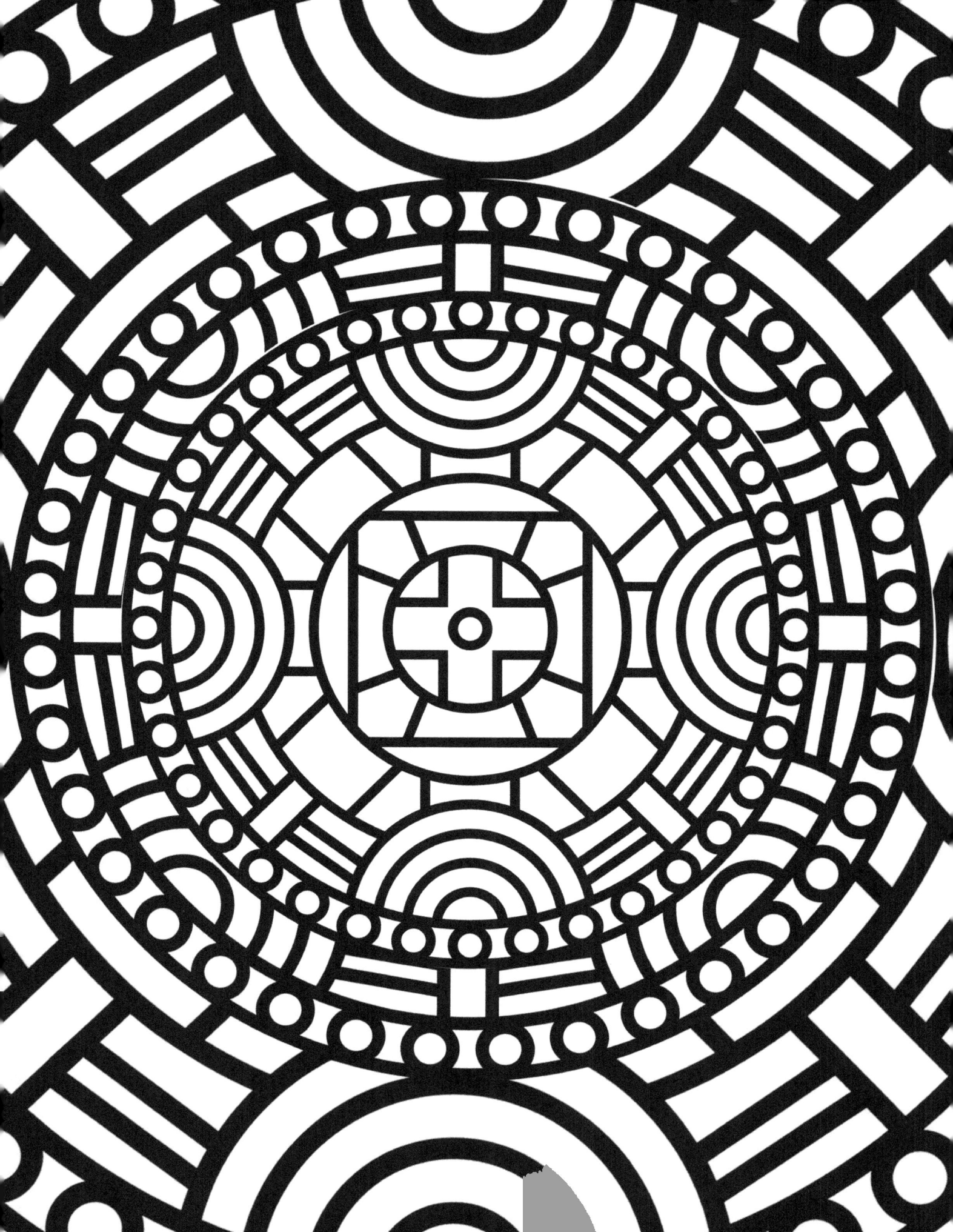

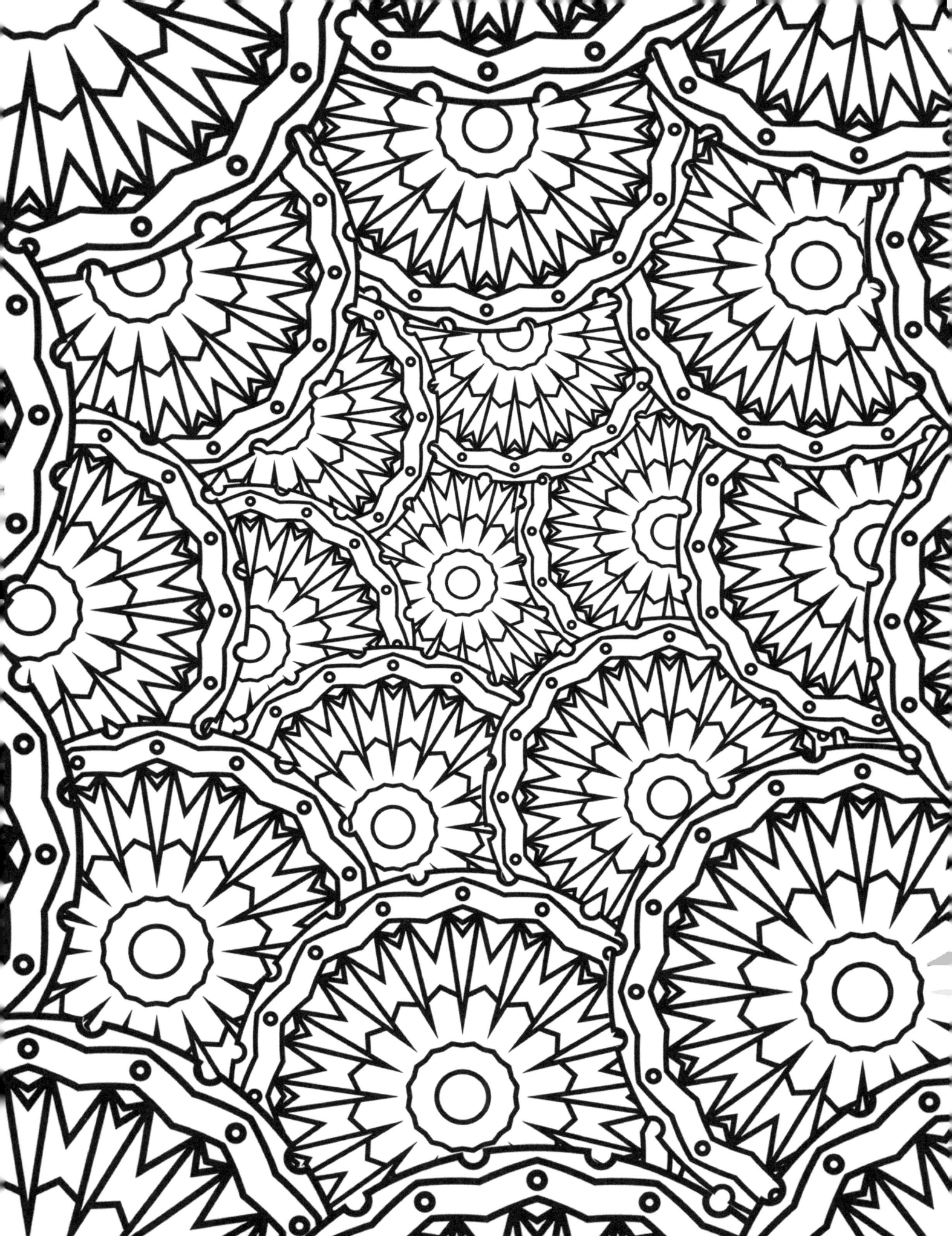

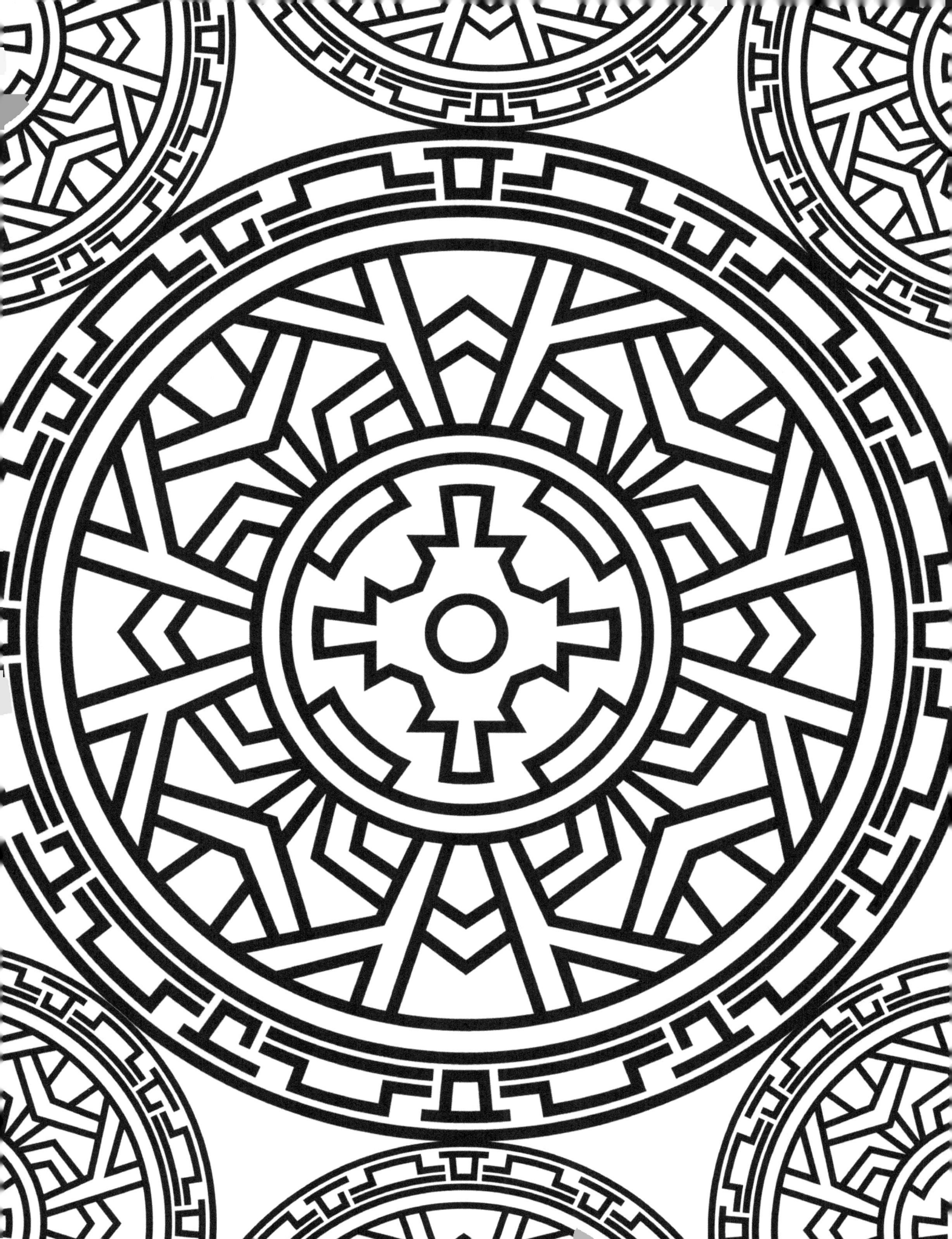

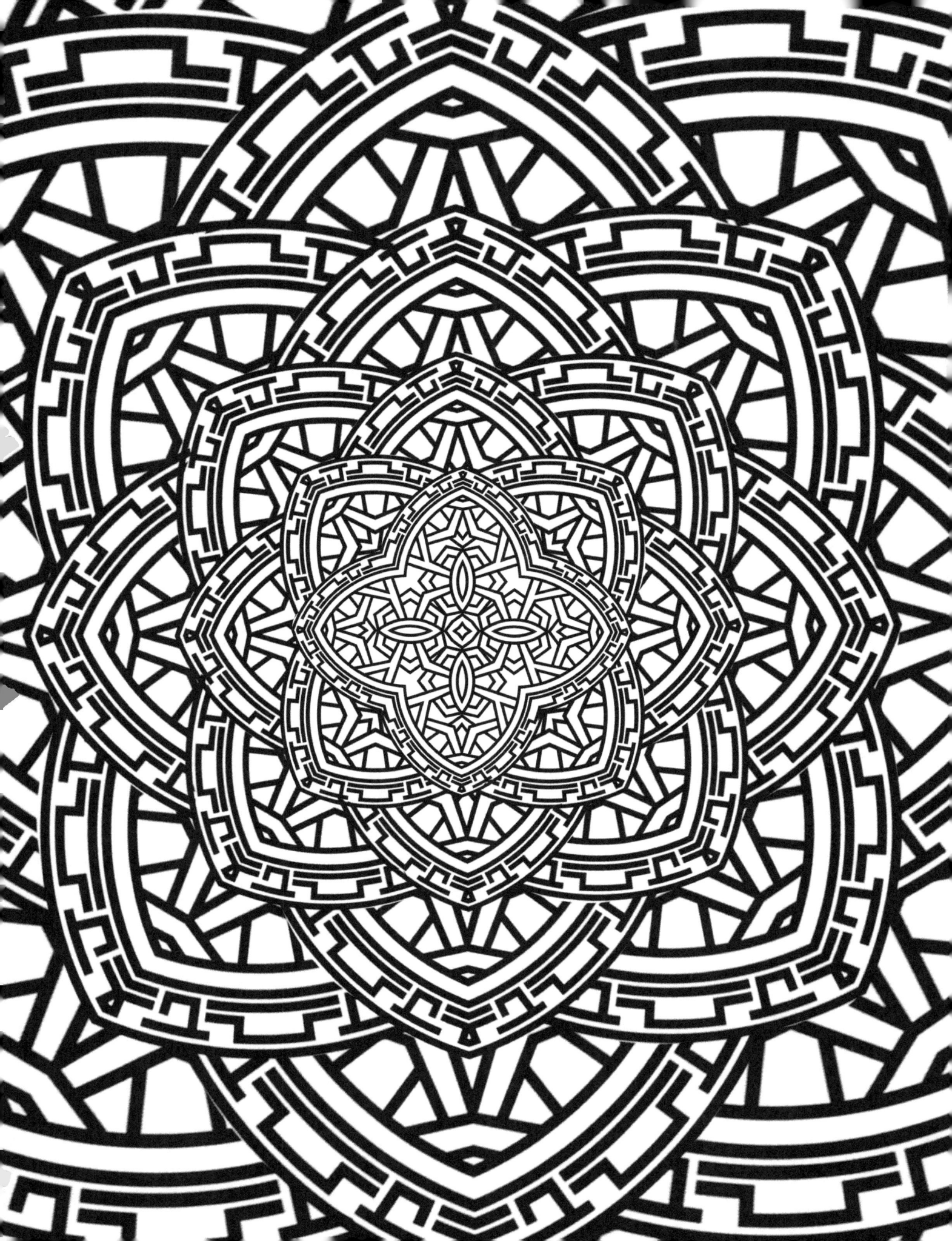

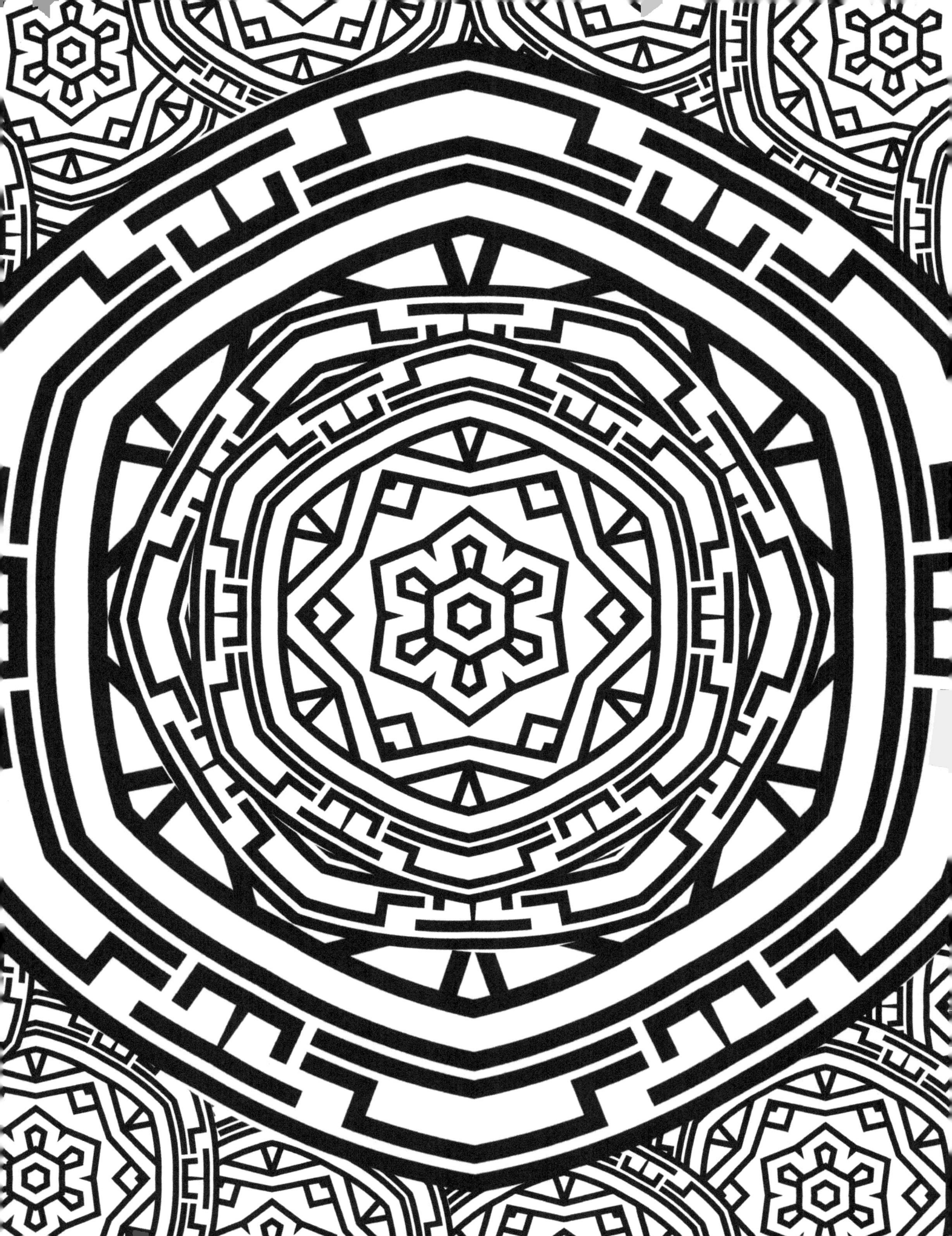

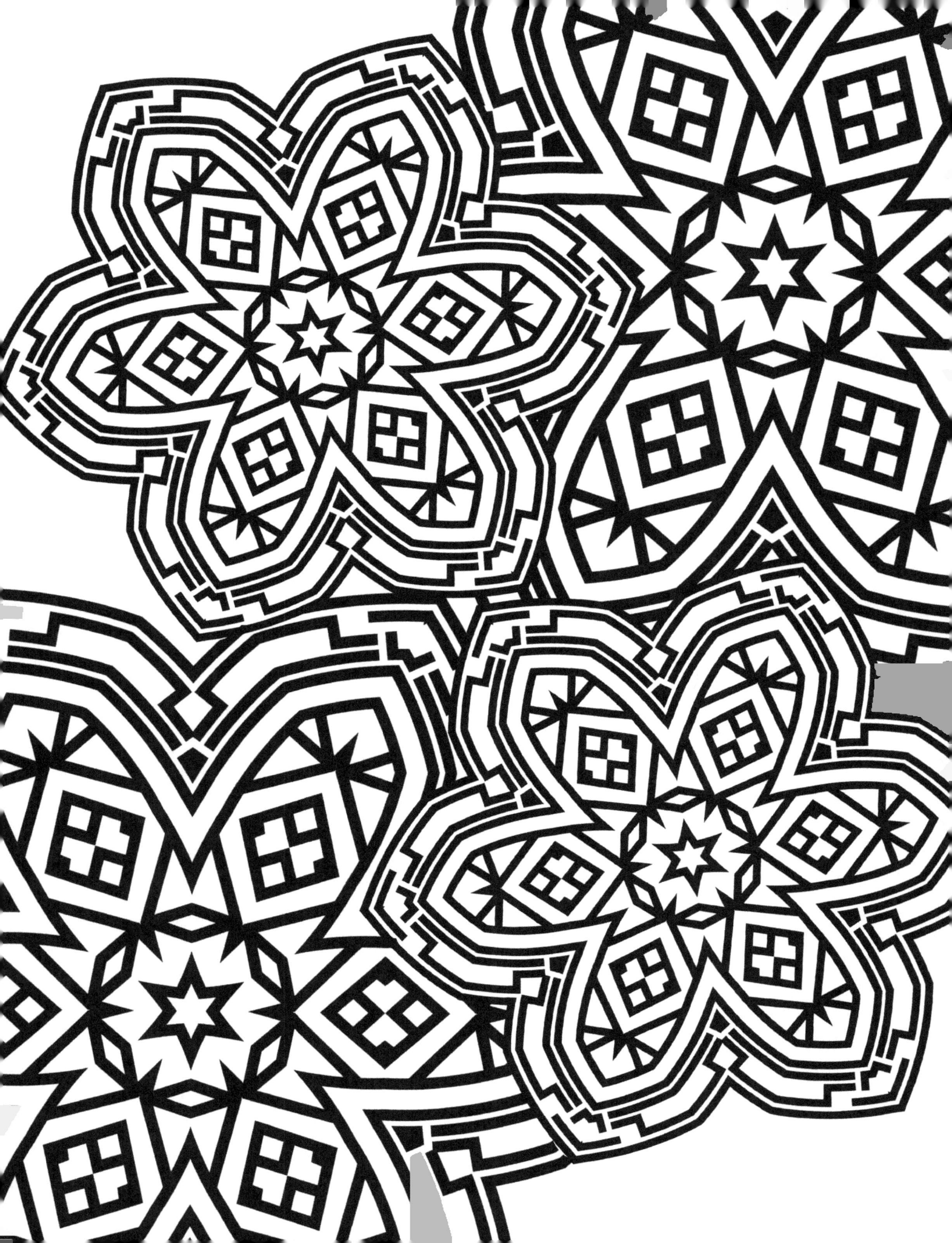

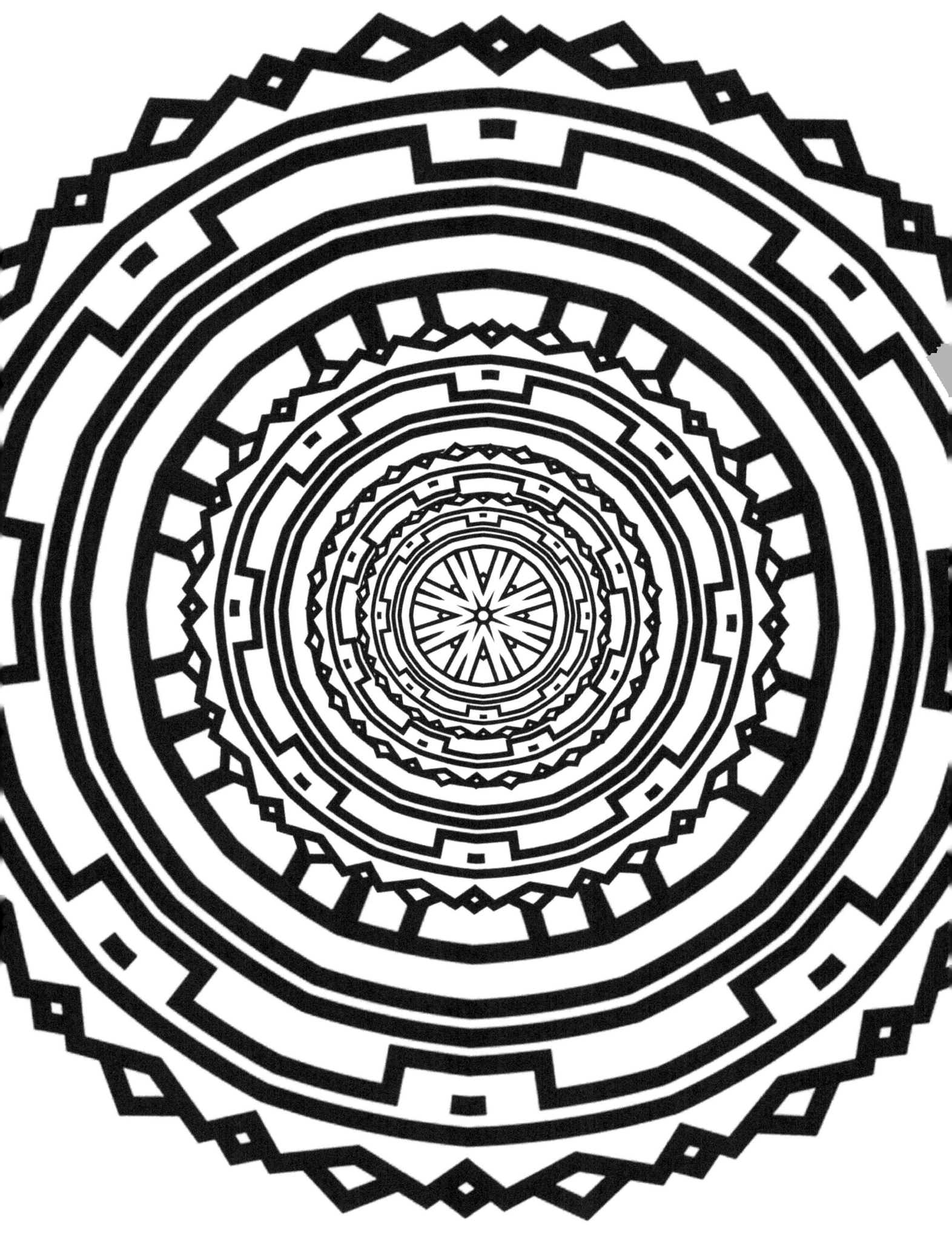

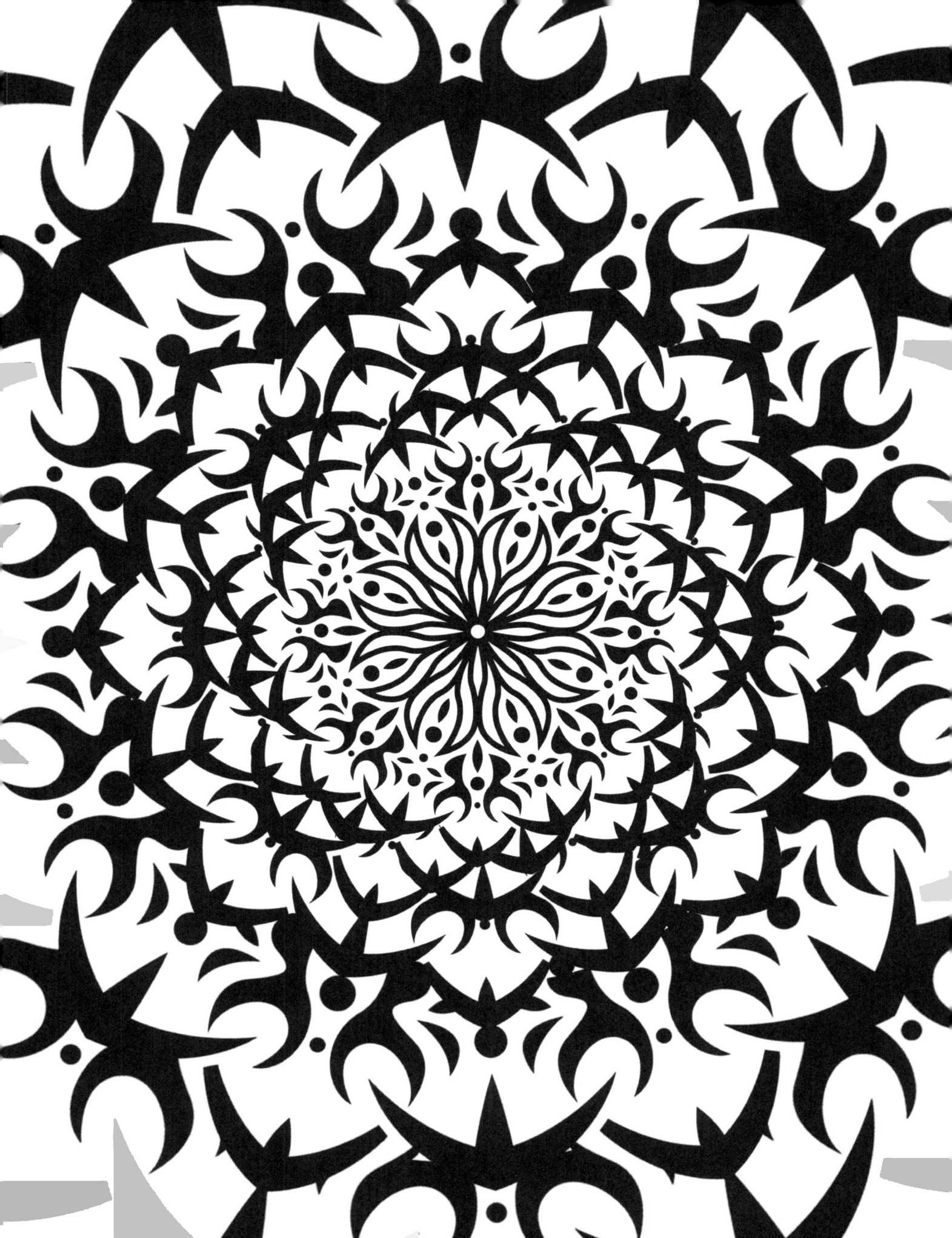

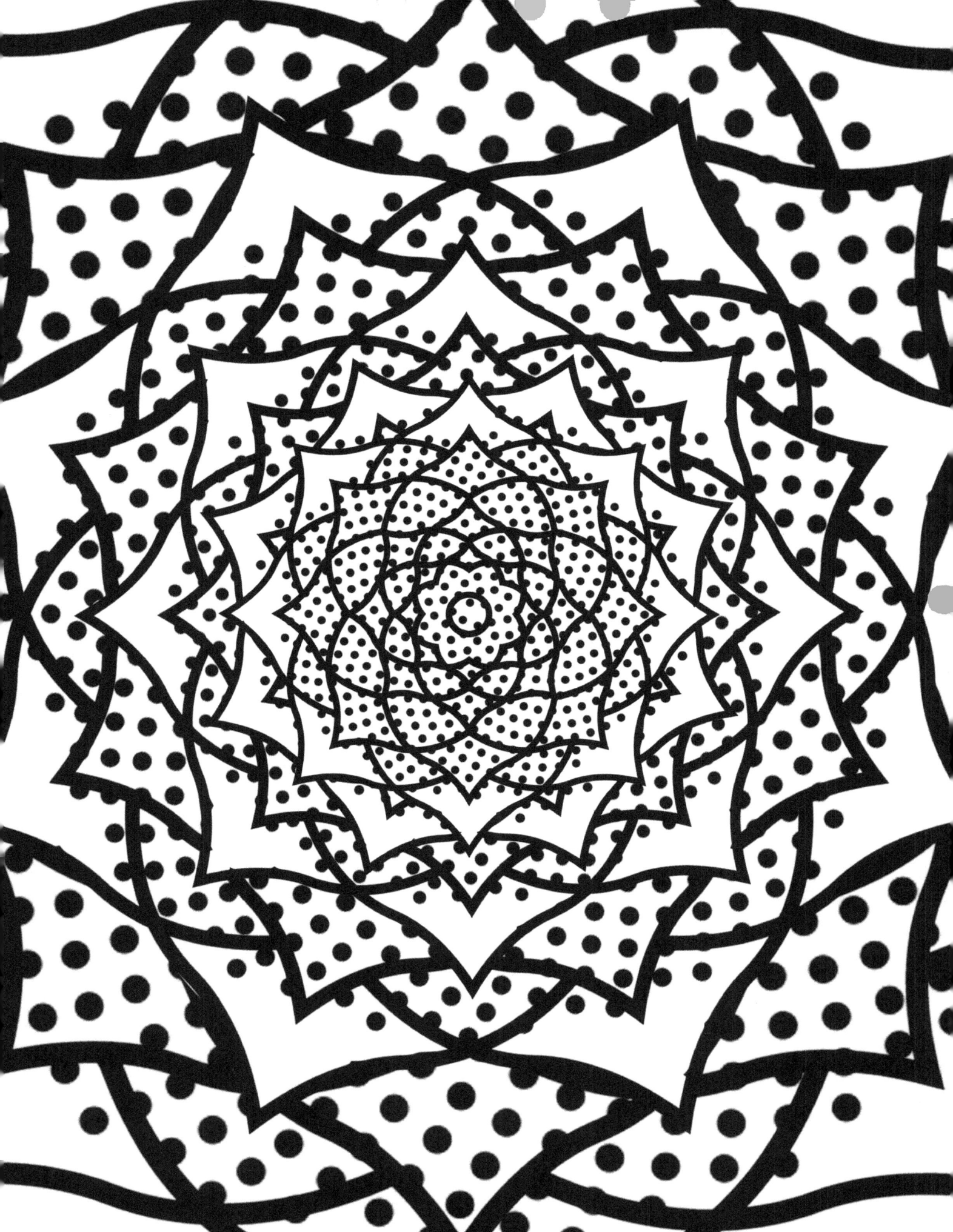

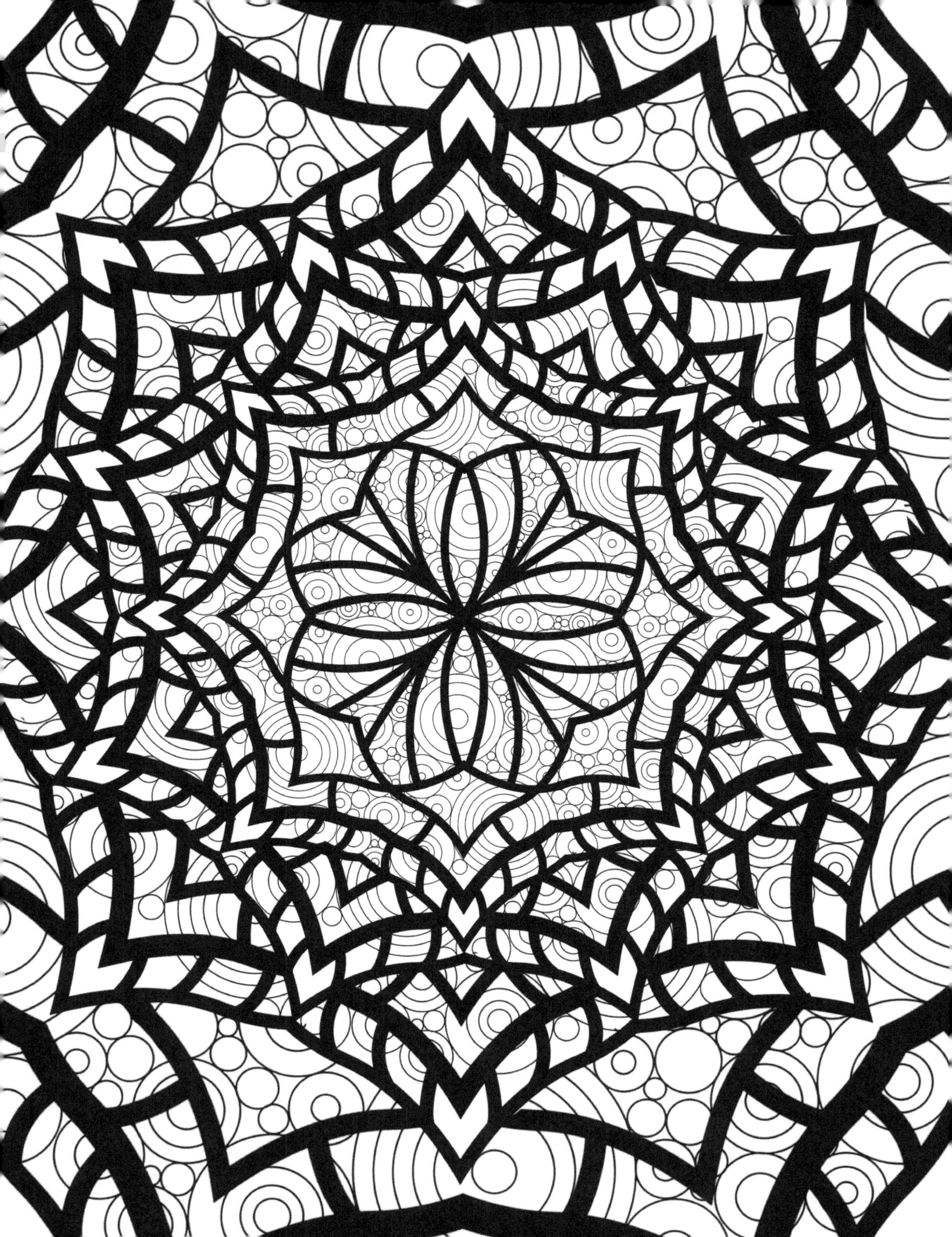

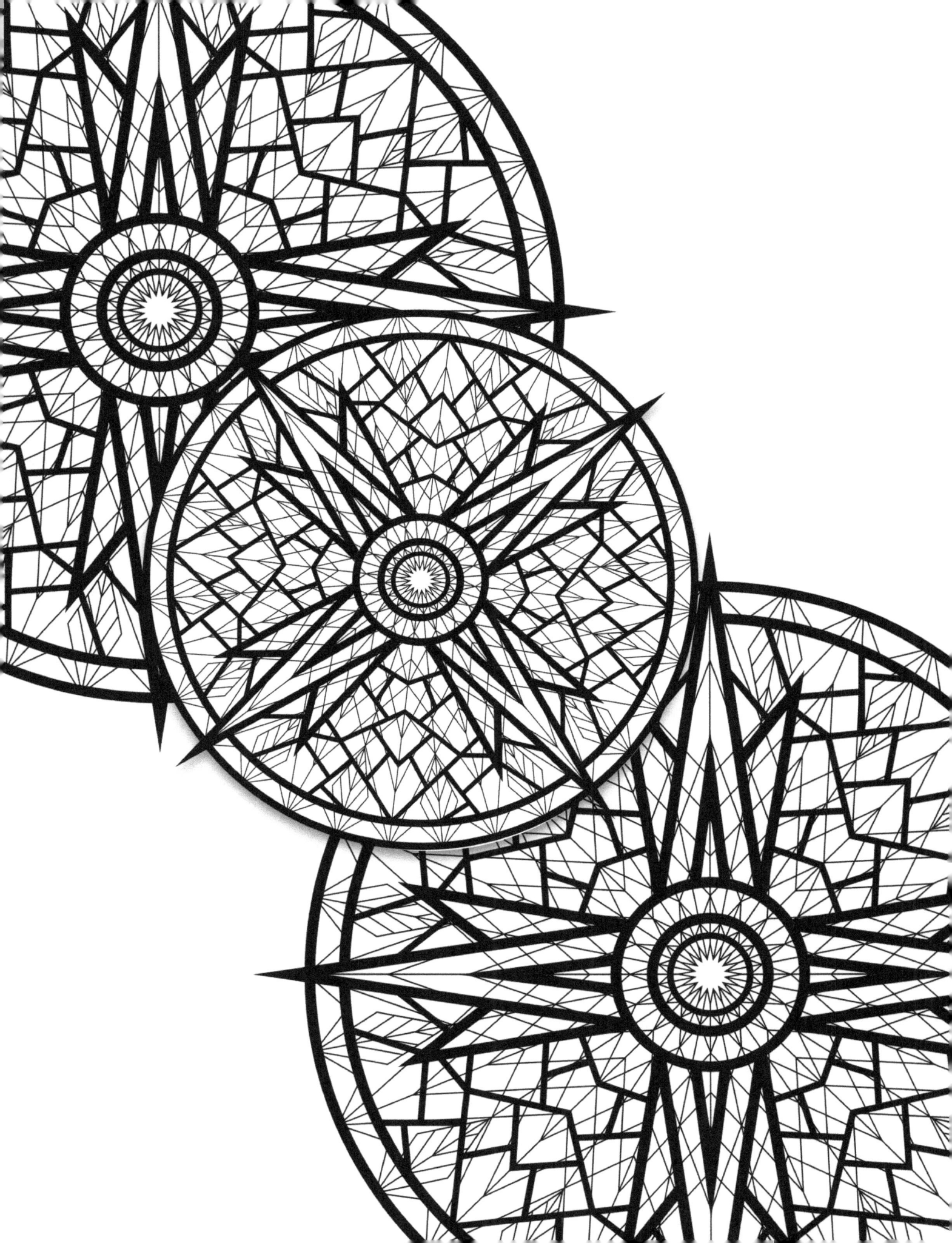

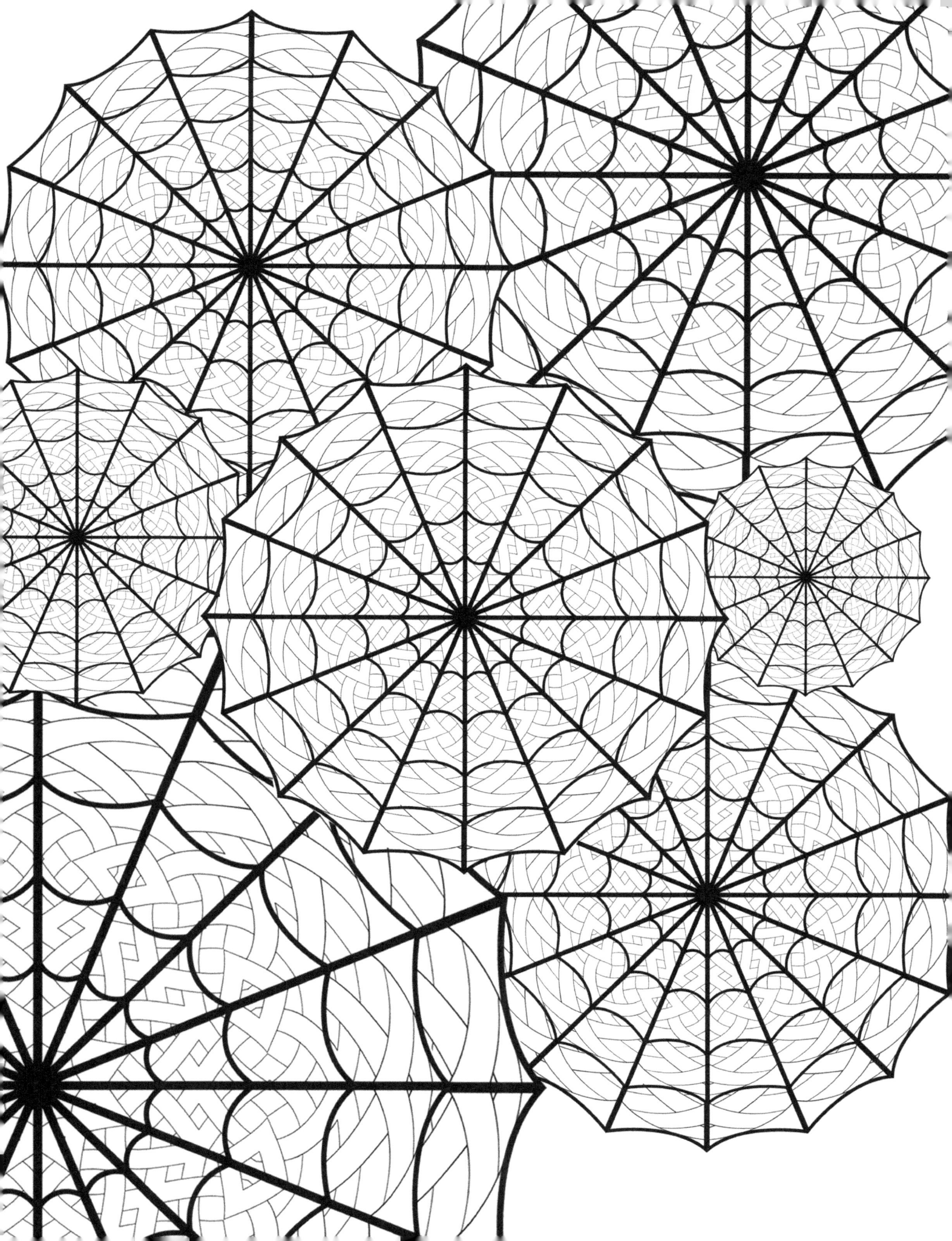

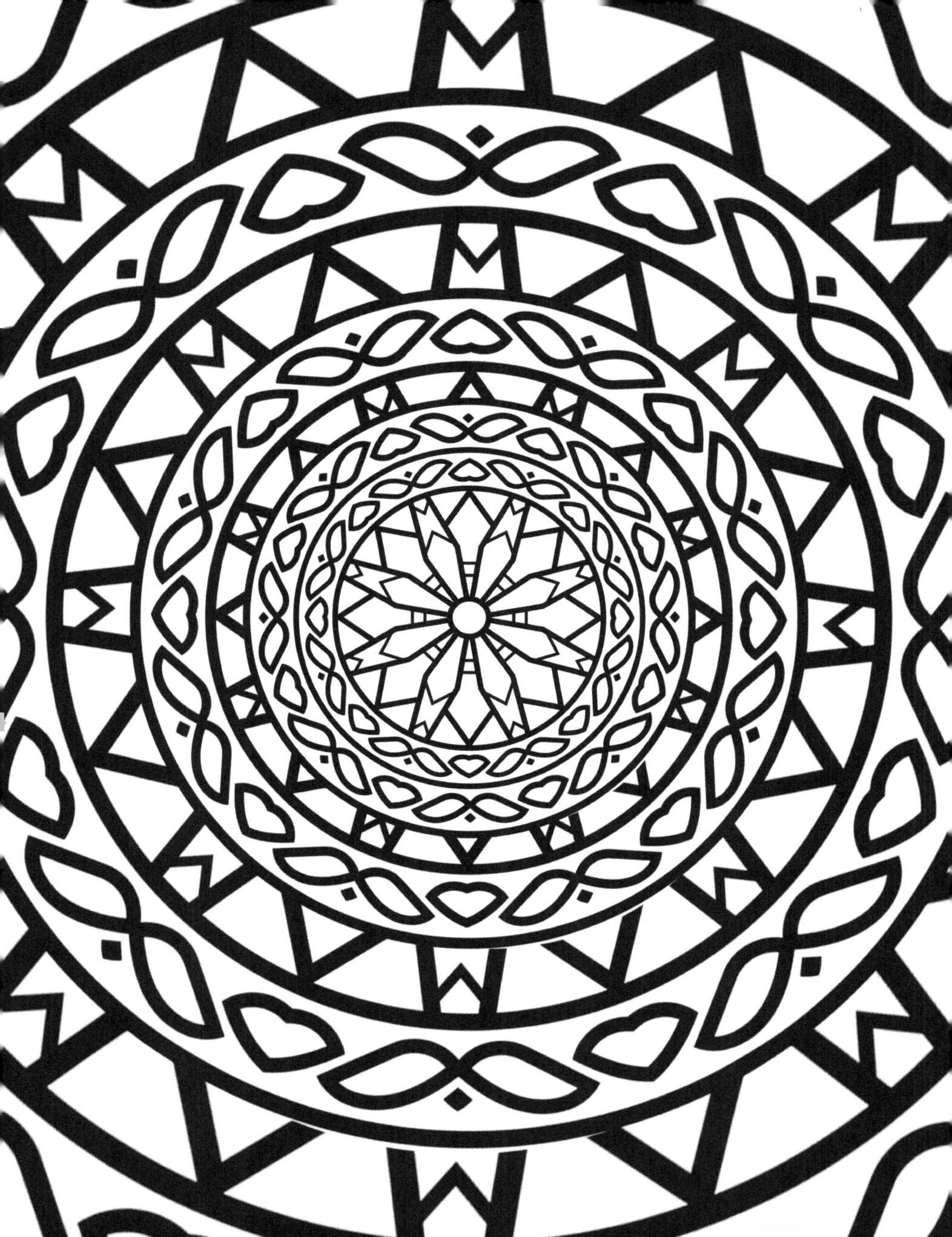

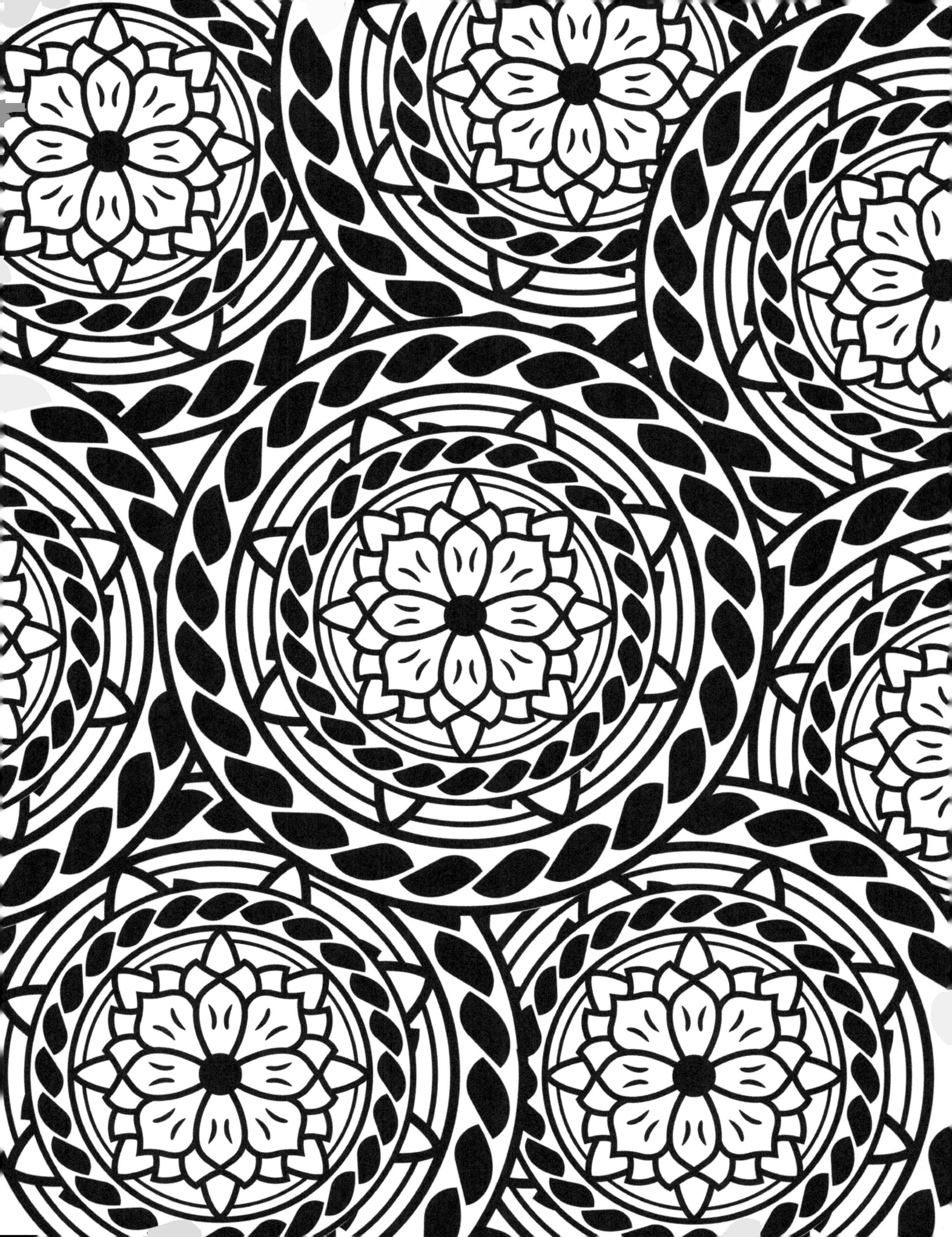

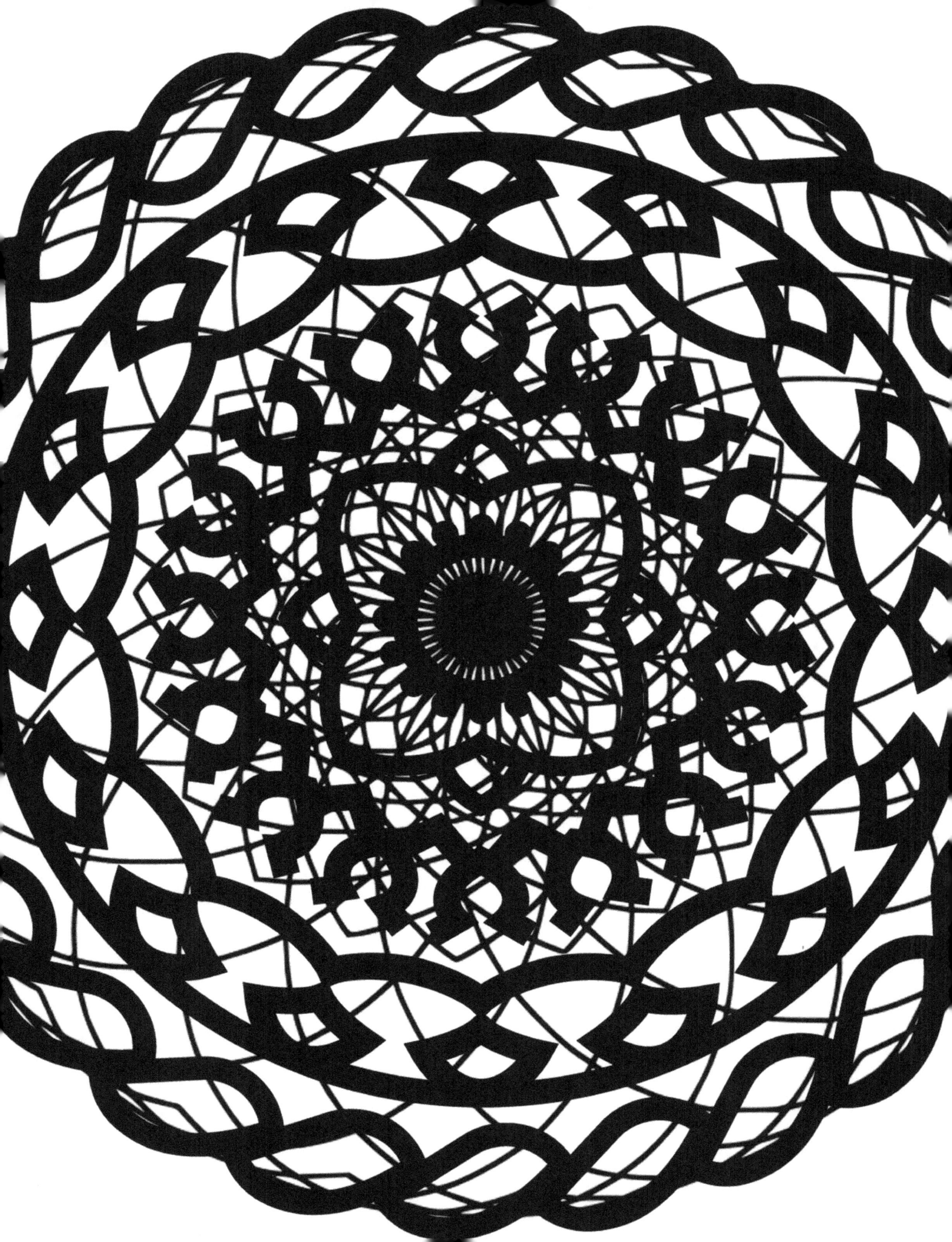

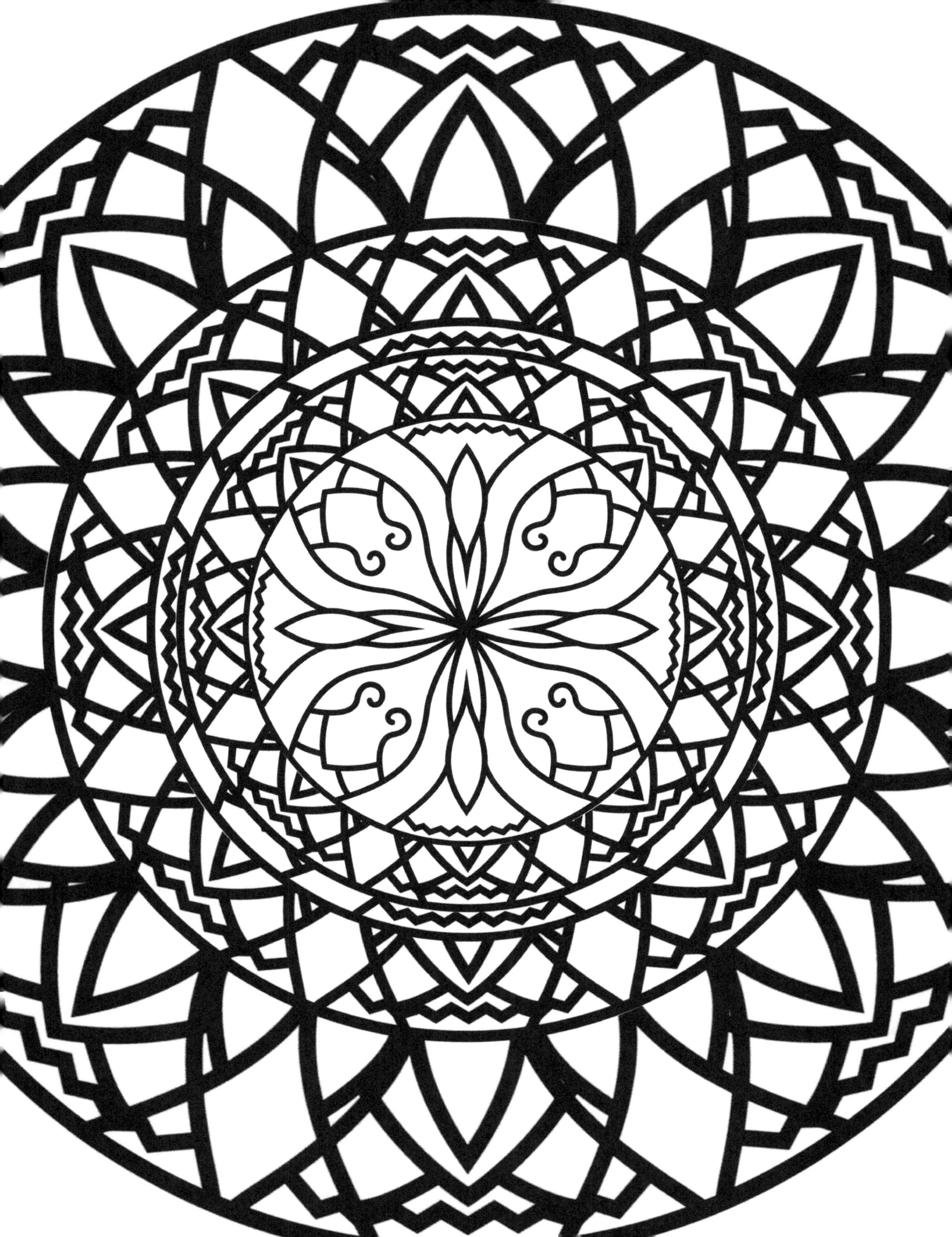

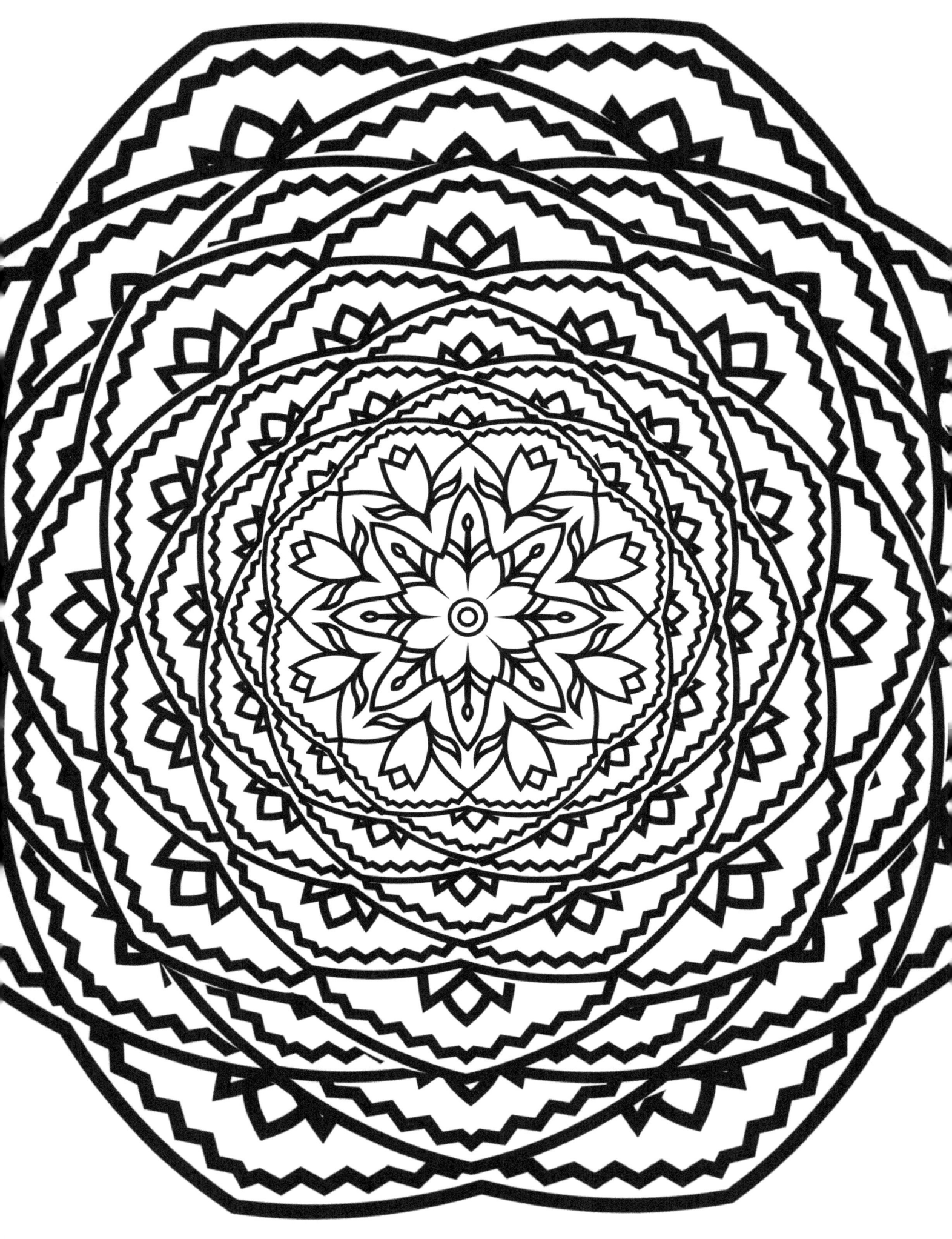

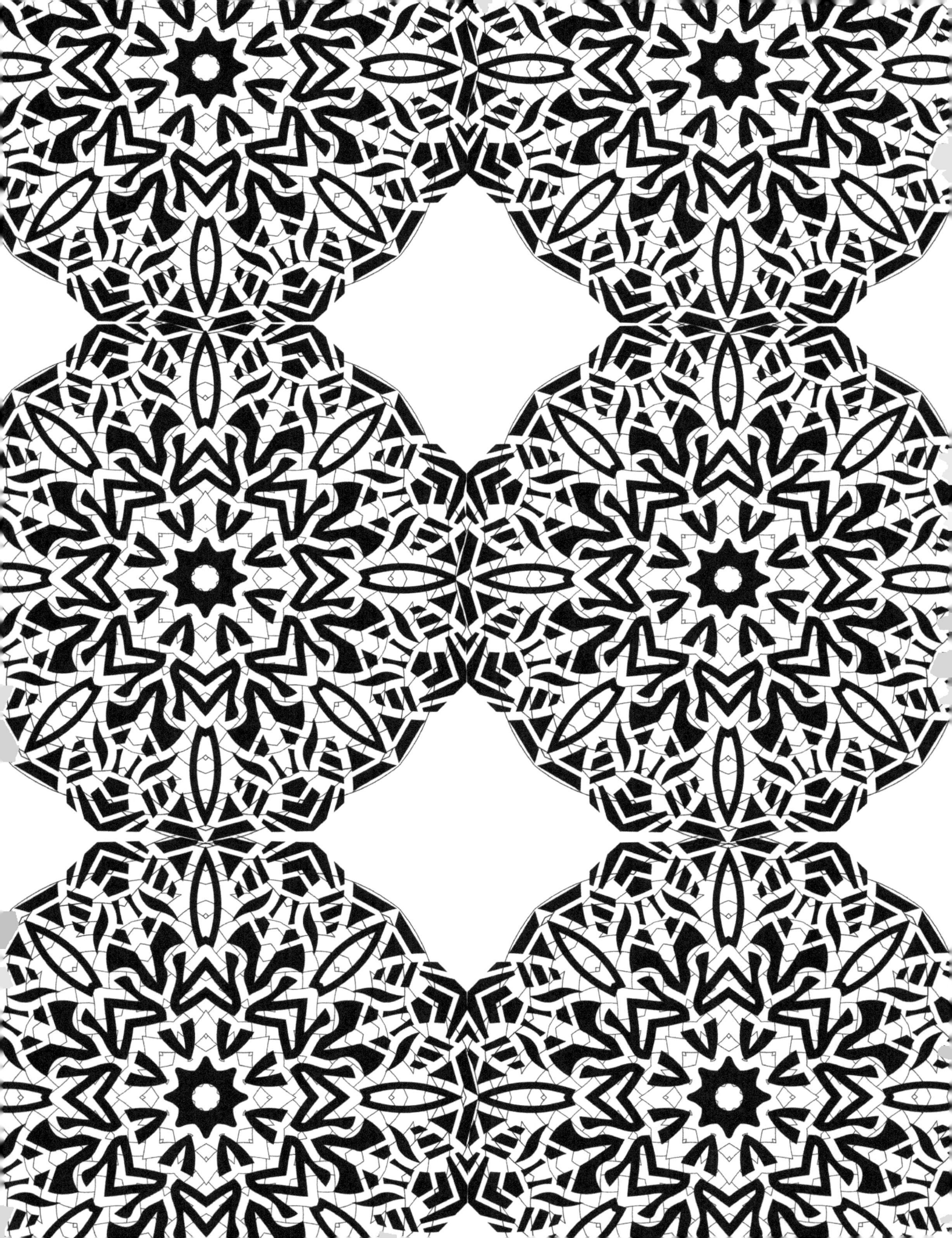

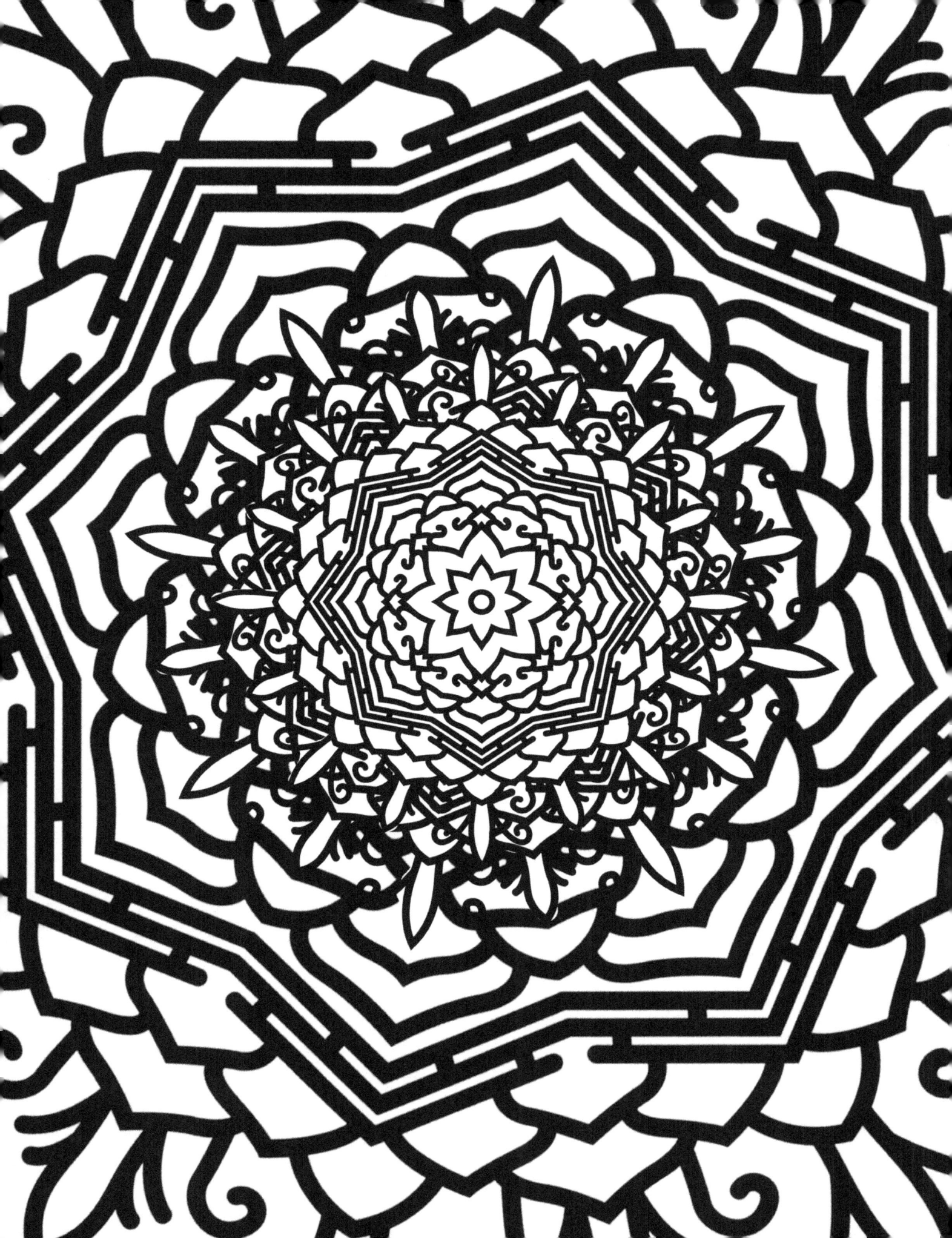

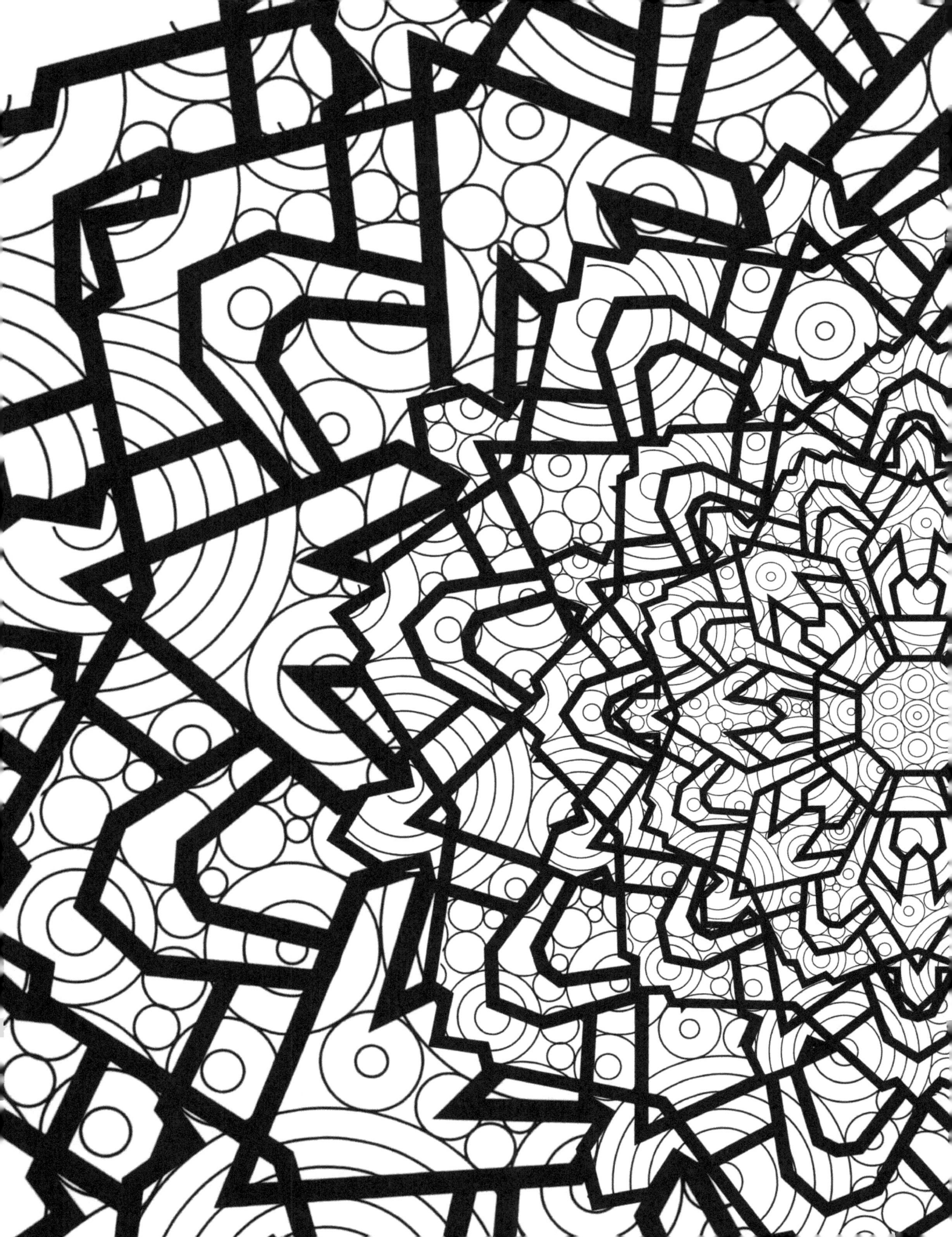

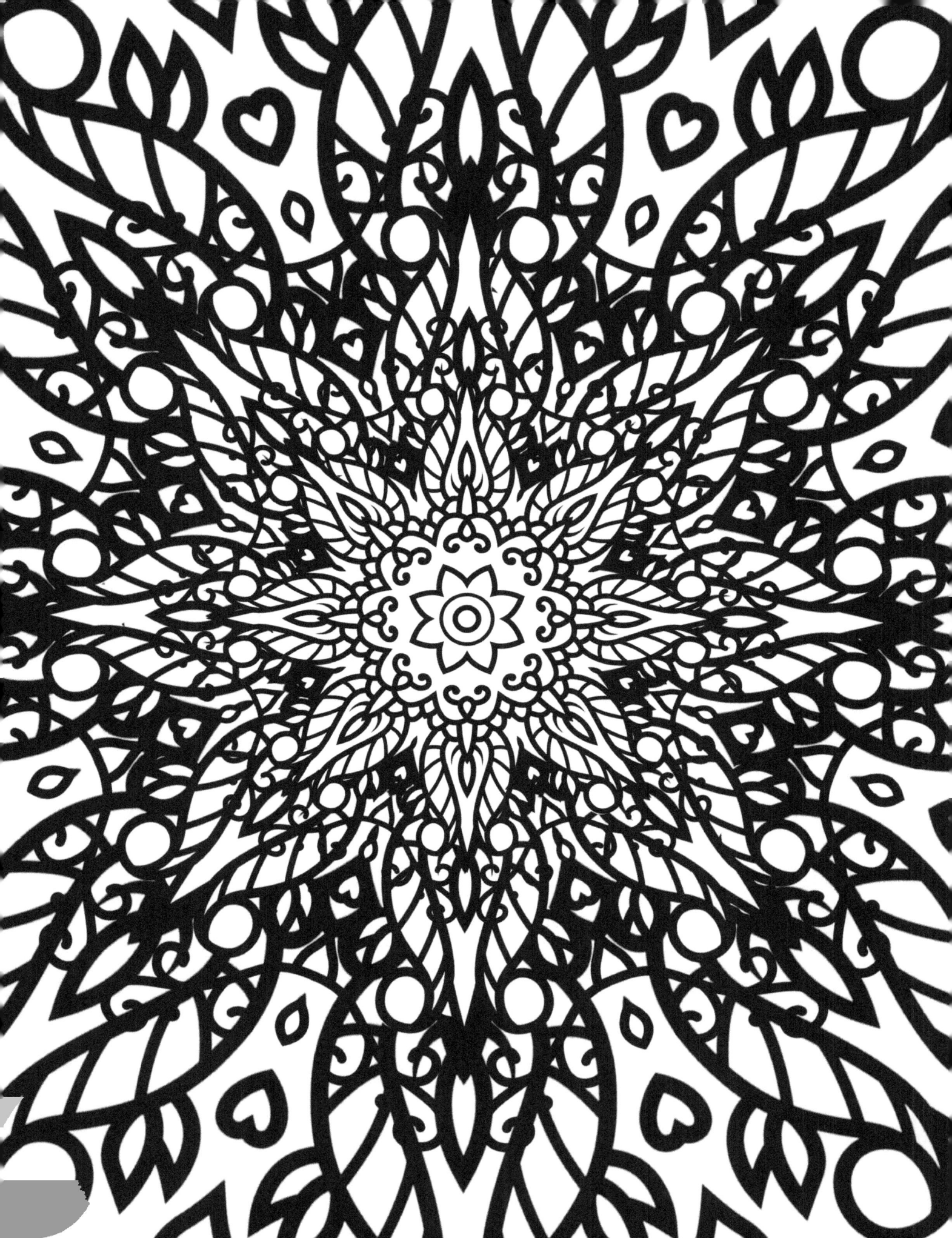

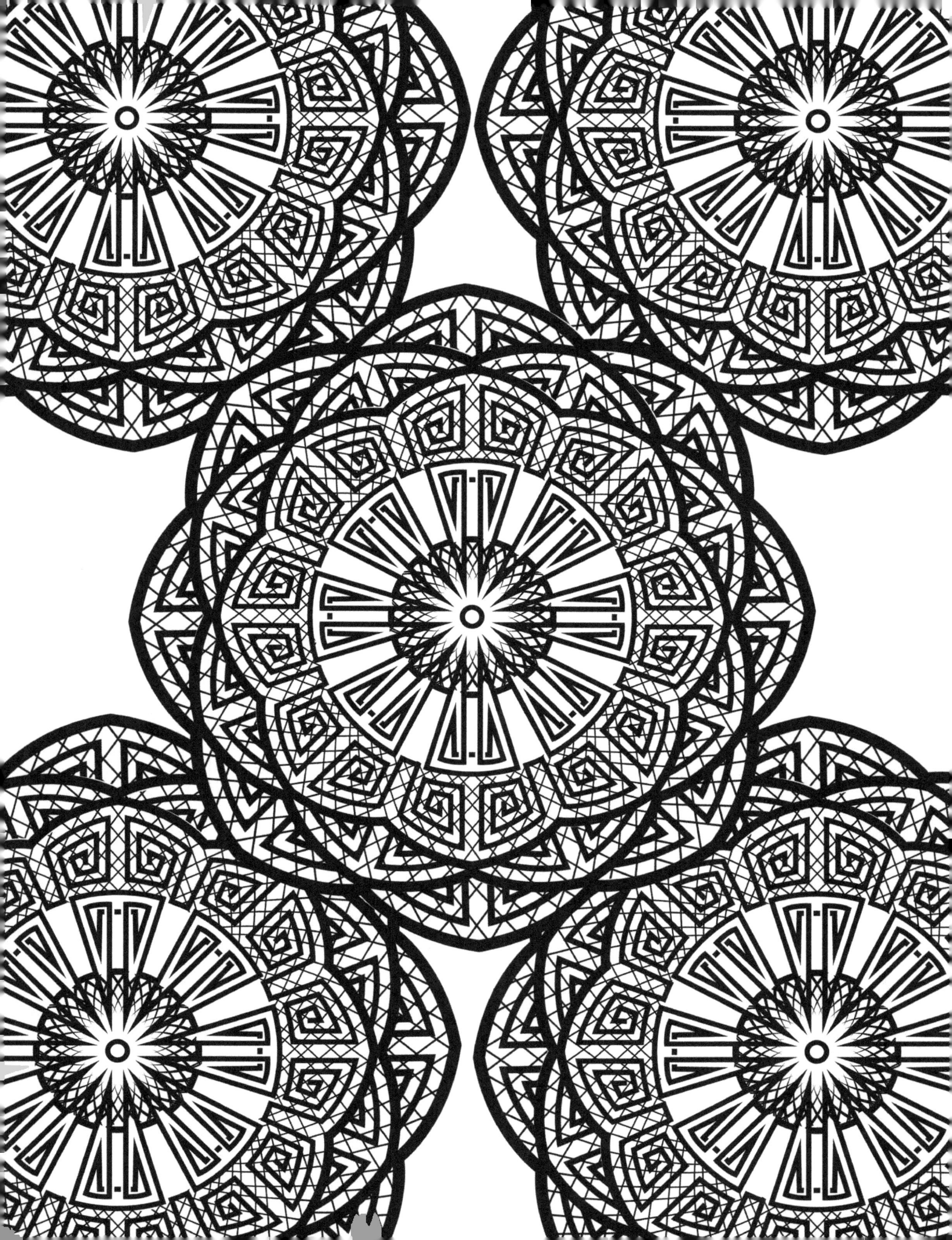

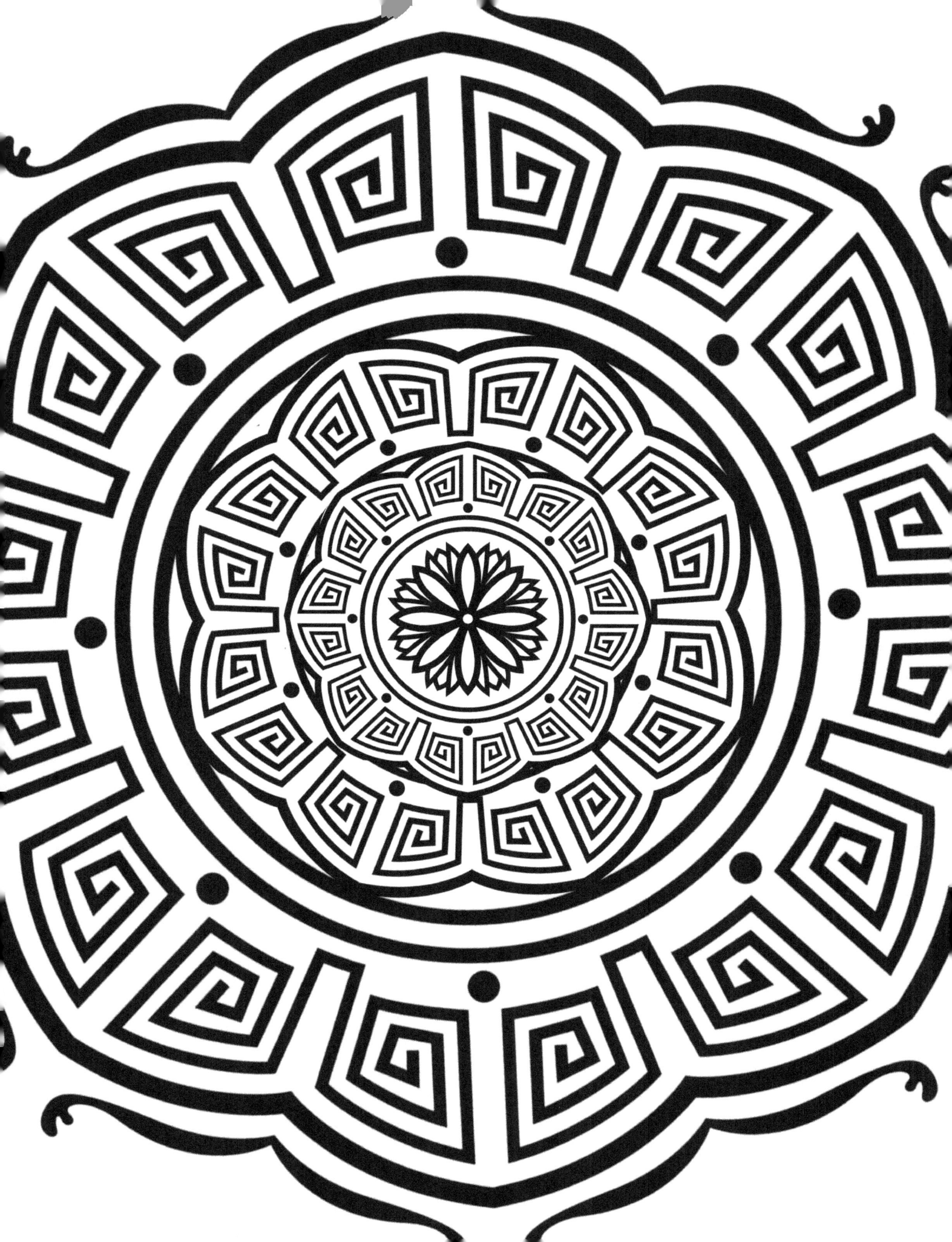

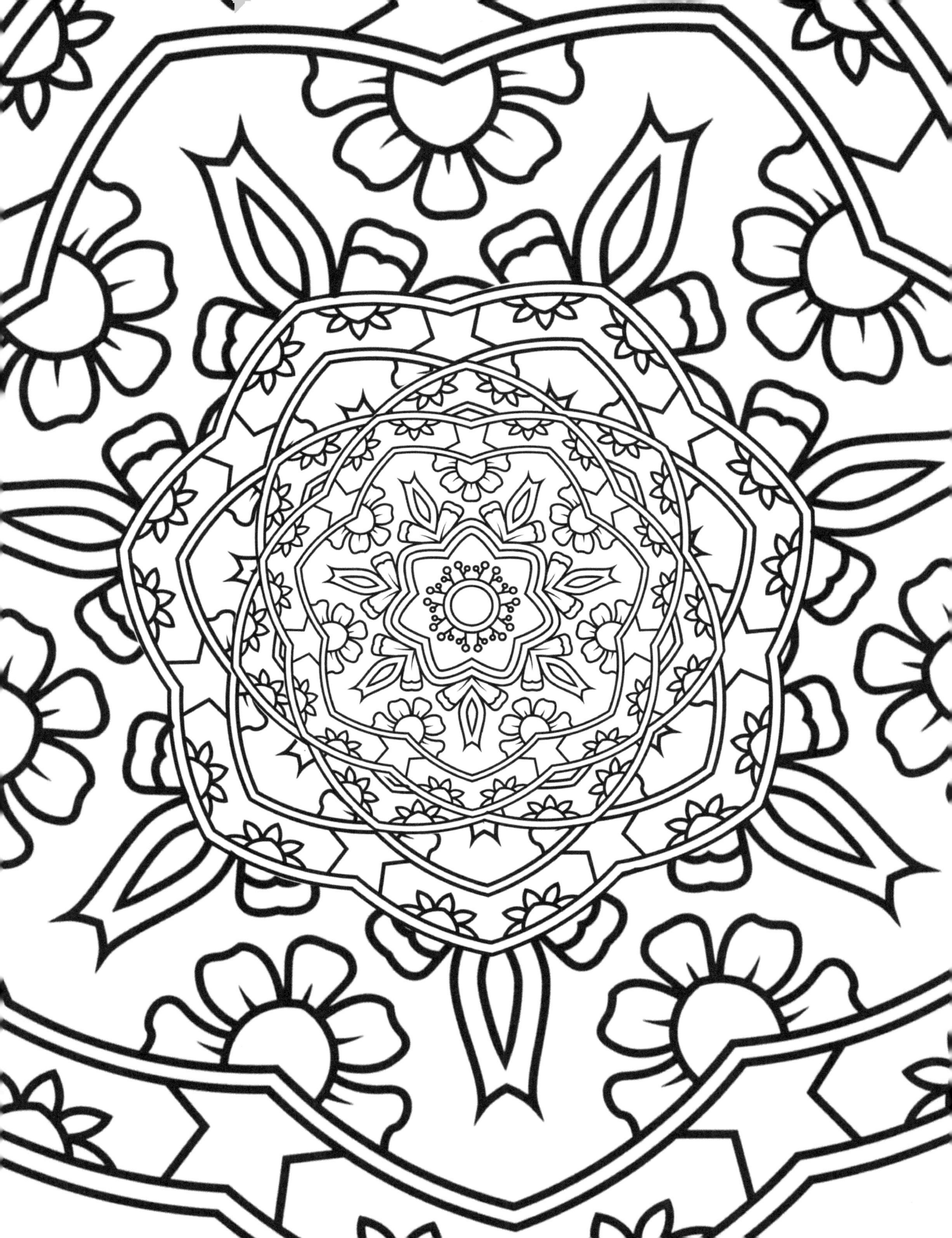

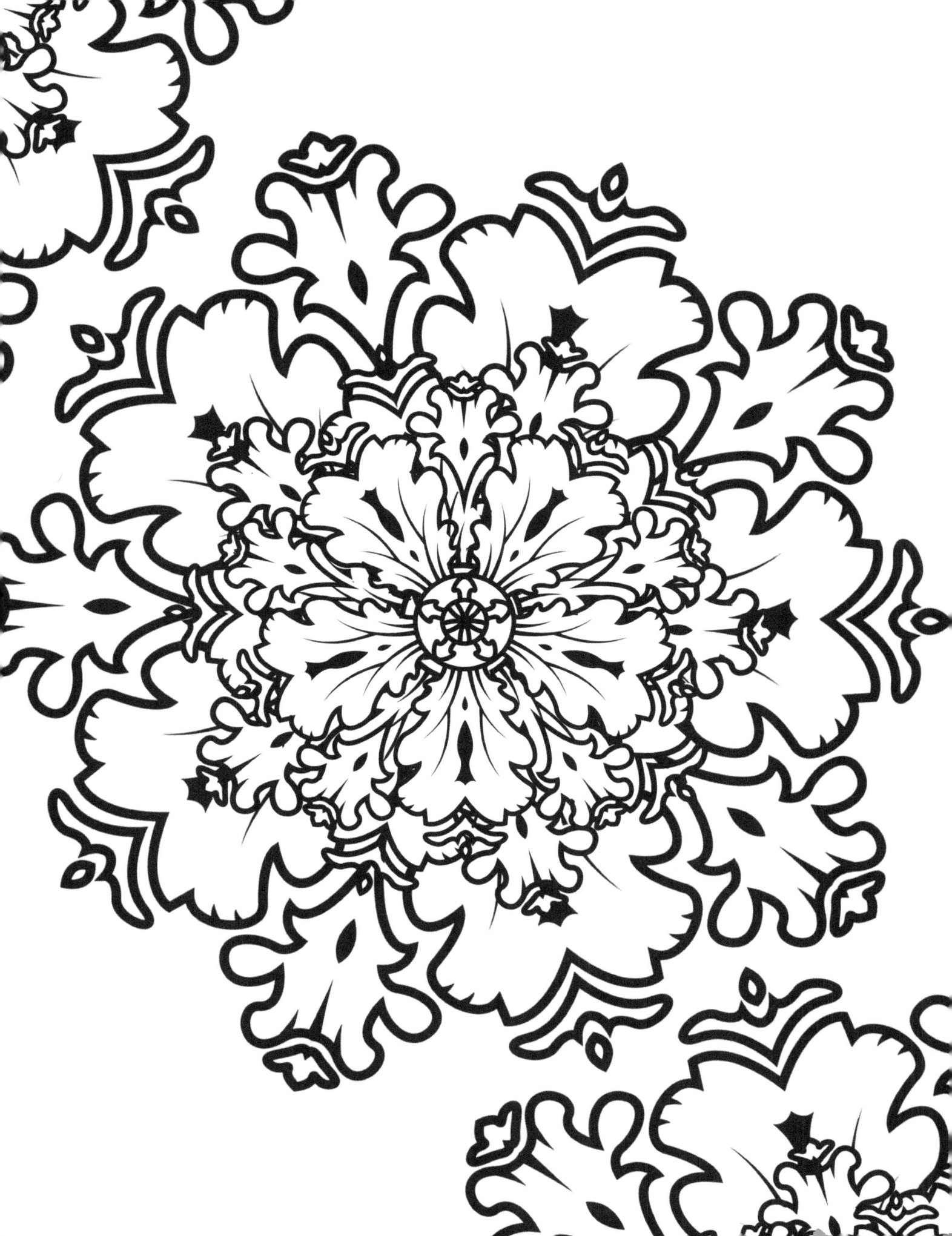

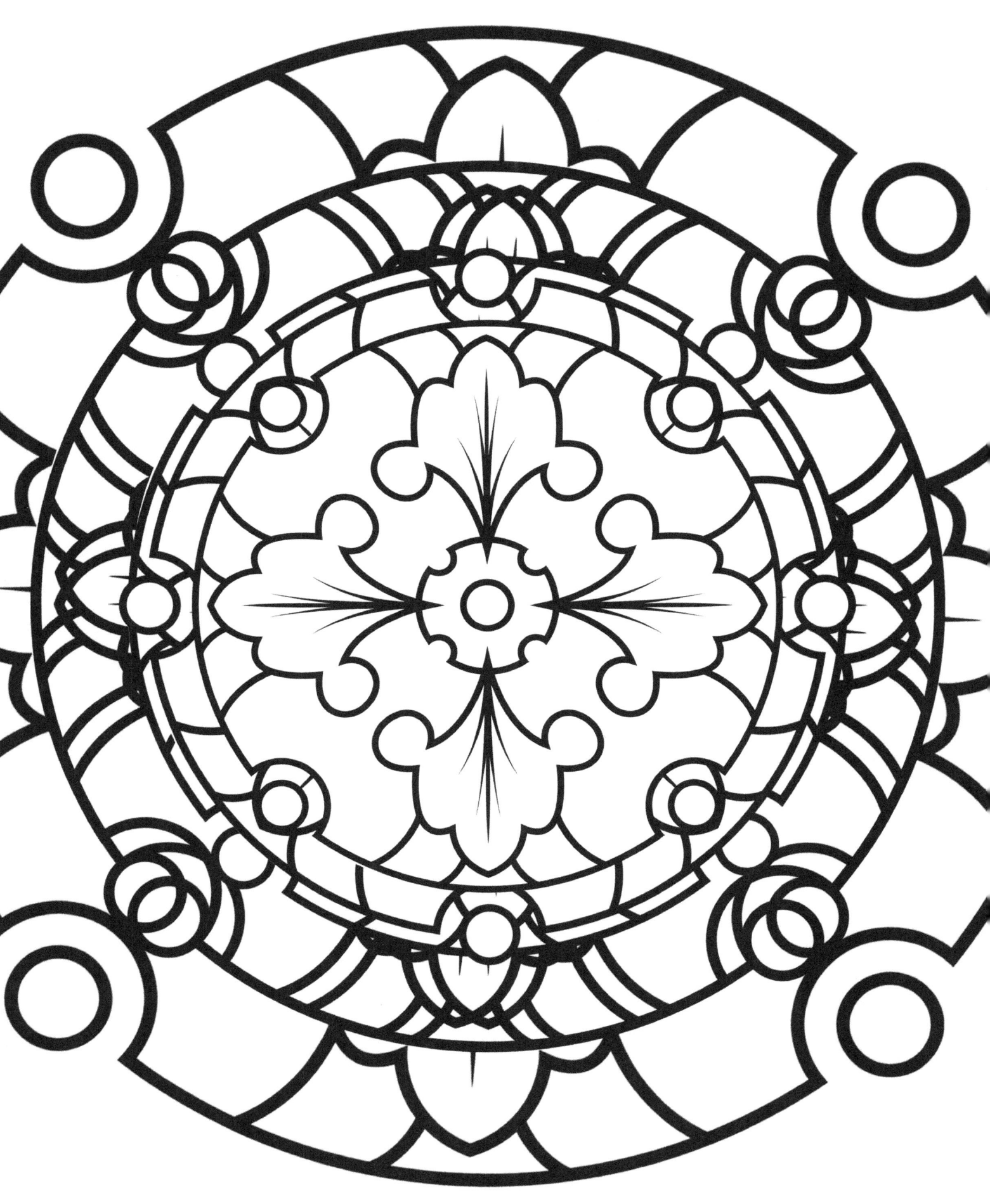